A VICTIM OF
ANONYMITY

A VICTIM OF ANONYMITY

THE MASTER OF THE SAINT BARTHOLOMEW ALTARPIECE

NEIL MACGREGOR

THAMES AND HUDSON

*For Terence Hodgkinson,
who has inspired many to study German art,
with gratitude and affection
on his eightieth birthday*

The Walter Neurath Memorial Lectures, up to 1992, were given at Birkbeck
College, University of London, whose Governors and Master most generously
sponsored them for twenty-four years.

First published in the United States in 1994 by Thames and Hudson Inc.,
500 Fifth Avenue, New York, New York 10110

Library of Congress Catalog Card Number 93-60981

Printed and bound in Great Britain

It was appropriate that this, the twenty-fifth Walter Neurath lecture, should have been given in the National Gallery. In founding Thames and Hudson, Walter Neurath was acting on his belief that an informed enjoyment of art should be available to the widest audience, and above all to the non-specialist. And it was of course precisely the same conviction that motivated those politicians and collectors who, in 1824, ultimately persuaded a hesitant British government that a public collection of pictures was a desirable, indeed essential, part of a modern society.

After studying in Vienna, Walter Neurath came to England in 1938. He was part of that heroic group of men and women who brought to this country the noblest traditions of the German-speaking world, who, among other things, transformed the study of art history in English and who, at a crucial moment, reminded the world that German culture is an indispensable part of the European story. It was for this reason that I chose as my subject an aspect of the history of German art, or, more precisely, a problem which has, I believe, proved to be a serious obstacle to its study in this country.

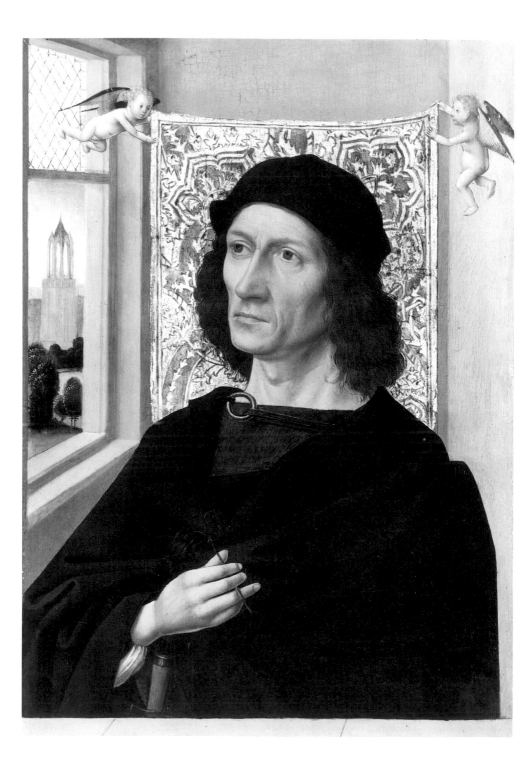

MY PURPOSE HERE is to celebrate an anonymous artist, three of whose works hang in the National Gallery.[1] Unlike the 'famous men' of *Ecclesiasticus*, he has left no name behind him that his 'praises might be reported', and his life cannot be reconstructed. He is known only as The Master of the Saint Bartholomew Altarpiece.

He is, I believe, one of the great European artists of the late fifteenth century, who deserves to be far more widely known and studied. The quality of his work and the impact of anonymity on his reputation will be my main themes.

Like every major collection of paintings, the National Gallery was until recently organized by national school. This system has the great virtue of clarity – visitors are likely to know whether the artists they want to look at are French, Spanish or British, and will therefore know where to start looking. There is, however, a cost. Art can too easily seem to develop in terms of the nation states that we know today, so that we often miss connections between artists working at the same period but in different places: in such a scheme van Eyck, for example, hangs near Rubens, but far from Antonello.

In deciding to hang in the Sainsbury Wing the early paintings of all the different European schools, it was hoped to make it easier for the visitor to grasp the close links between fifteenth-century works made in Italy or Germany, the Netherlands or France.[2] In terms of subject matter, and the devotional uses that pictures served, this new arrangement has helped to clarify patterns common to the whole of Europe. The constant movement across the Alps of ideas, and indeed pictures, is now apparent, and the different national or regional schools can easily be seen to form part of a European whole. The greatest beneficiaries of these new arrangements will very likely be the German paintings, which in the past

1 MASTER OF THE SAINT BARTHOLOMEW ALTARPIECE, *Portrait of a Man*. Wallraf-Richartz Museum, Cologne (32.5 × 22.5 cm)

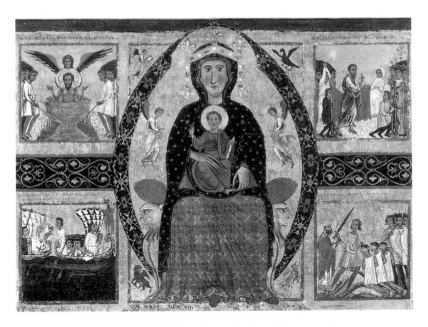

2 Margarito, *Virgin and Child* (detail). National Gallery, London

laboured under the disadvantage of hanging far from the celebrated Italian paintings of the same date, and far also from the main entrance to the gallery. No doubt many visitors had succumbed to aching feet and tired eyes long before they reached Titian, let alone Lochner. But most of these paintings suffered also from a second handicap, considerably less evident than physical distance, but just as grievous – the absence of a name.[3]

On entering the Sainsbury Wing, the first picture a visitor will see, probably the earliest in the whole collection, is Margarito's *Virgin and Child*, boldly inscribed in the centre below the Virgin's throne, 'Margarit' de Aritio me fecit'. A little further on, Niccolò di Buonaccorso informs us, in an inscription that faithfully reflects the throaty c's of his Tuscan accent, that 'Nicholaus: Bonachursi: de Senis: me pnxt'. In the next room Pisanello has spelt out his abbreviated authorship in the weeds at the feet of Saints George and Anthony: 'pisanus pi'.

8

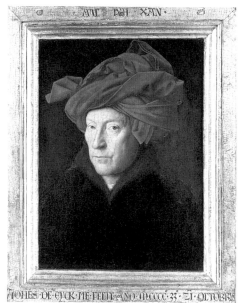

3,4,5 Three signatures: details from Pisanello's *Saints George and Anthony* (below) and Antonello's *Christ Crucified* (bottom); and Jan van Eyck's *Man in a Turban* (right), with its inscription on the frame. All in the National Gallery, London

And this liking for self-statement is not confined to Italy. In the following room Jan van Eyck has devised three different strategies for announcing his authorship, recording his abridged name on the painted parapet of the so-called *Timotheos* portrait on 10 October 1432 and on the frame of the *Man in a Turban* on 21 October 1433, before calligraphically 5 intruding on the Arnolfinis' space and signing on their back wall with his full name and the year 1434.

So it goes on, with Antonello's '1475 antonellus messaneus me pinxit' on a fictive label apparently stuck to the picture surface just below 4 the foot of the cross, and Crivelli, eager to tell us, on the illusionistic strip of parchment at the base of the *Madonna of the Swallow* both where he was born and to which class he now belongs: 'Carolus. Crivellus. Venetus. Miles.' In room after room, we have the impression of artists burning to let us know who they were and when they made their picture.

Until, that is, you come to the German room. Here not a single picture is signed, and only three can with any confidence be attributed to

9

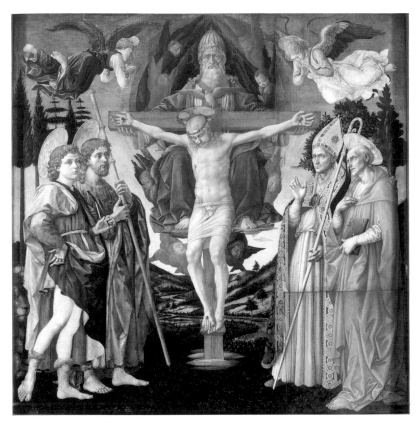

6 FRANCESCO PESELLINO, *The Holy Trinity*. National Gallery, London
(184 × 181.5 cm)

named artists at all – Lochner, Dürer and Pacher. The others are all by artists without names. It is a change that is both astonishing and disconcerting.

And it is by no means the end of the matter. In the case of many of the pictures in the Italian rooms of the Sainsbury Wing we know not only who the artists were, but also a great deal about the making of the particular works. We have full contracts – confusingly full in some cases – for commissions such as Duccio's *Maestà*, painted for the cathedral in Siena, and Sassetta's double-sided altarpiece for the Franciscans of

Borgo San Sepolcro. We even know how much the eggs cost that went to make the tempera for the San Pier Maggiore Altarpiece, while the treasurer of the confraternity that commissioned Pesellino's *Holy Trinity* 6 obligingly left a document explaining why the bewilderingly recherché Saint Mamas had been included – because they needed an extra saint to make a symmetrical foursome, and he, the treasurer, had a particular devotion to this Early Christian martyr.[4]

When we come to the German room, we are once again in a totally different world, a world with no contracts (for our paintings at least), indeed, with virtually no documents of any kind directly relating to surviving works.[5] Here and there the name of a sitter is inscribed: we know, for instance, that the anonymous Swabian painter has represented a woman of the Hofer family,[6] and that the rebarbative man in the black 7 hat was called Alexander Mornauer.[7] But, on the whole, the pictures 8

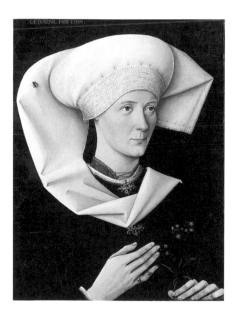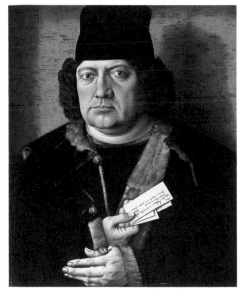

7 Unknown Swabian painter, *Portrait of a Woman of the Hofer Family*. National Gallery, London (53.7 × 40.8 cm). 8 MASTER OF THE MORNAUER PORTRAIT, *Portrait of Alexander Mornauer*. National Gallery, London (45.2 × 38.7 cm)

themselves carry little information, the surviving documents offer little support and, more than in any other room in the Sainsbury Wing, we are on our own. Why so great and so sharp a difference between the Germans and the rest?

In part it is the National Gallery's own fault. The same discrepancy can be observed in other collections, but it is exacerbated in London by the way in which the National Gallery Collection was put together in the middle decades of the nineteenth century, with a marked preference for works that could be securely placed in a historical sequence and could thus form the basis of a didactic display.[8] The three van Eycks in the National Gallery, signed and dated (two of them to the day), are rare in the extreme and were acquired to a large extent for this specific reason.

But it is also a problem for all northern art: judging from surviving works, it does seem to be the case that northern artists on the whole signed less frequently than their Italian contemporaries. It is possible too that they tended to sign on the frames, as van Eyck did with the *Man in a Turban*, or on separate labels that were then glued to the pictures ⁄ the *trompe⁄l'oeil* signatures in the Crivelli and the Antonello must presumably have represented a practice once actually current. Real, stuck⁄on labels would of course fall off, and it is only on very rare occasions that fifteenth⁄century paintings survive with their original frames intact. So northern signatures may have been frequent, but simply too easily detached from their pictures. Above all, however, the problem arises because the bulk of the National Gallery's early German pictures come from Cologne, and Cologne was in many respects a highly idiosyncratic city.

Cologne

9 A woodcut of 1475 shows the view of the city that was to remain familiar for centuries.[9] The great bulk of the unfinished cathedral stood, effectively unchanged, through the seventeenth century (when it was
10 shown in just this state by van der Heyden),[10] until the early nineteenth, when it was at last completed. In the last quarter of the fifteenth century, Cologne's population was around 40,000, making it almost certainly the

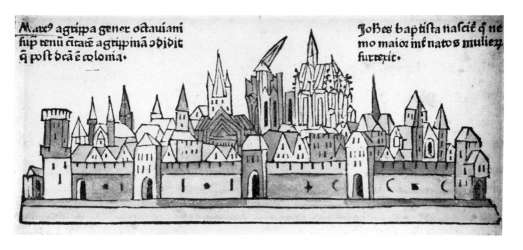

Maxⁱ agrippa gener octauiani
fup tenu citate agrippinā odidit
q̄ poſt dcā ē colonia·

Johēs baptiſta naſcit q̄ ne
mo maior mē natus mulier̄
furrexit·

9,10 Views of Cologne. *Above*: A woodcut of 1475; *below*: a painting of *c.* 1660 by JAN VAN DER HEYDEN, National Gallery, London (33.1 × 42.9 cm)

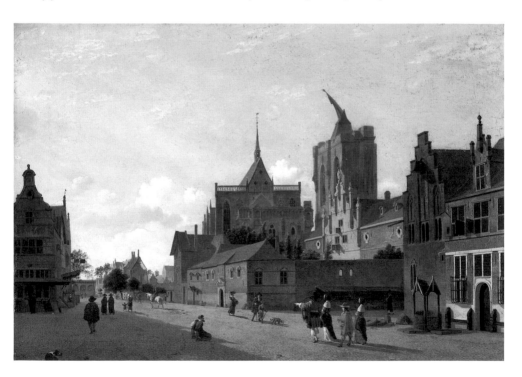

most densely populated city in Germany, and it was probably the biggest in area in Europe north of the Alps. Its position on the Rhine had made it extremely rich, not least because of the Stapelrecht, a shrewd regulation imposed by the Archbishop in 1349 requiring all goods going up or downstream to be unloaded, stored and taxed at Cologne, thus ensuring a constant source of revenue.[11]

Besides being a commercial centre, it was of course a great church city. The seat of the archbishop, with large numbers of churches and monastic foundations, it also owned some of the most enticing relics in all Christendom. The bones of the Magi, transferred from Milan in 1162, had become the most precious possession of Cologne Cathedral, while the relics of Saint Ursula and her eleven thousand martyred virgins were also held in the city. The fascination these in particular exerted on the European imagination was intense and enduring. Even as late as the mid-nineteenth century, Maupassant's short story 'La Relique' tells of a lover who is commanded by his fiancée to steal one of their bones as a test of his affection. Eager that his fiancée should not be the eleven thousand and first virgin, he endeavours (but in vain) to fulfil her wish.

This combination of commercial and religious activity made Cologne one of the greatest artistic centres in the Empire. In his *Parsifal*, the thirteenth-century Minnesänger Wolfram von Eschenbach describes the painters of Cologne and Maastricht as proverbially the best in Germany, an observation quoted in the nineteenth century by both Friedrich von Schlegel and Goethe.[12] A great deal of painting is known to have been produced there in the fifteenth century and, because of the relatively tranquil Reformation in Cologne and the city's good fortune in the Thirty Years' War, a larger number of high-quality works have survived from Cologne than from any other major centre in Germany.

But almost all these works are anonymous. It was clearly not the custom to sign paintings (frames may have been another matter), and no relevant contracts are known. It is a relatively common characteristic of northern trading centres such as Cologne that contracts are made orally rather than in writing, which may explain why, although painting contracts from centres in the south of Germany are not rare, not a single

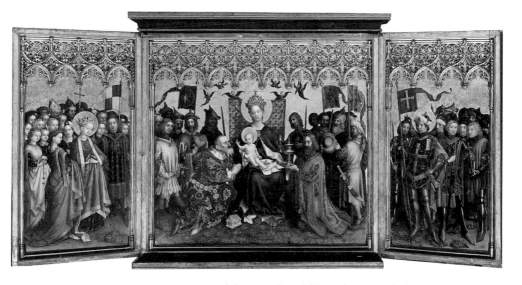

11 STEFAN LOCHNER, *The Adoration of the Kings (Dombild)*. Cologne Cathedral (central panel: 238 × 263 cm; wings: 234 × 118 cm)

contract for a Cologne painting of this period survives. Archives there are in plenty, with many documents about artists, but no contracts. Given the level and quality of Cologne's artistic production, it is a cruel lack.

Thanks to the efforts of one of the heroic archival researchers of the nineteenth century, we know a great deal about the artists, if not about their works. For nearly fifty years, from the 1840s to the 1890s, the Cologne art historian Johann Jacob Merlos combed the city archives recording every reference to artists. He was able to establish their names, the names of those they married, where they bought their houses and when they ran into financial difficulties. But after nearly fifty years of research he could not connect a single surviving painting with any of the artists' names.[13]

Indeed, the only major Cologne painting of the period which we can confidently attribute to a named artist is Lochner's *Dombild*, which 11 gathers together the city's principal cults by showing the Magi, Saint Ursula (with a selection from her eleven thousand followers) and another local saint, Gereon, adoring the Christ Child. And this work,

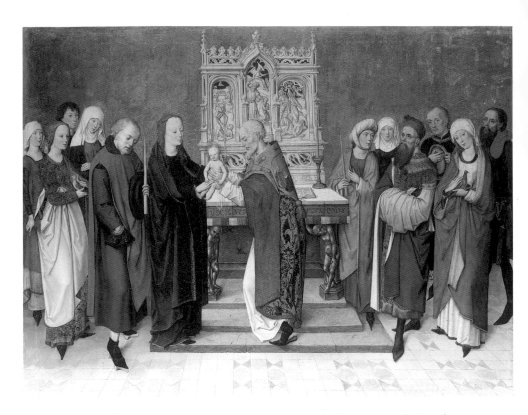

12 MASTER OF THE LIFE OF THE VIRGIN, *The Presentation in the Temple.*
National Gallery, London (84 × 108.5 cm)

which Goethe described as the pivot of German painting, we know to be
by Lochner only because of a reference in Dürer's notebook, where he
describes seeing the picture and being told it was by 'Meister Steffan'.[14]

One last element of confusion remains to be added to the story. After
the turmoil of the French revolutionary invasion, when Cologne was
forcibly incorporated into France, the violent secularization of both
churches and monasteries led to huge numbers of paintings being
removed from their original settings. The great pioneering collectors, the
Boisserée brothers, who started gathering these objects as they were
almost literally being thrown out of the churches, spoke of the event as
'ein ungeheurer Schiffbruch', a monstrous shipwreck, from which they

rescued what they could.[15] But while works of art could be saved, records often could not. In many cases we now know neither for whom nor for what location the paintings were made. And so, without artist, patron or place, Cologne pictures presented a particularly acute problem of taxonomy and categorization, beginning with a problem of names; for most of the paintings are called – in desperation – quite simply after themselves, by what the Germans call a Notname, an emergency name.

The painting of the *Presentation in the Temple* now in the National 12
Gallery, and one of the many saved by the Boisserées, makes the point. It was made in Cologne, probably in the 1470s, but we know nothing of its origins. It is, however, clearly part of a group of eight scenes of the life of the Virgin, of which the remaining seven are now in the Alte Pinakothek, Munich. The artist has therefore simply been named the Master of the Life of the Virgin.[16] On the basis of stylistic similarities, other works have been attributed to him, his artistic personality has been outlined and an oeuvre identified.

Similarly, the great three-panelled painting of Saint Bartholomew 13
with a Carthusian donor and standing saints, also now in Munich, provides the only name we have for the artist – the great artist – who is to be discussed here: The Master of the Saint Bartholomew Altarpiece.[17]

Do Names Matter?

One might ask whether it matters that an artist has no real name. I think it does. All kinds of celebrity are at once precluded. An anonymous artist, however distinguished, cannot enter the pantheons so eagerly constructed in the nineteenth century, whether in Delaroche's great Hemicycle in Paris or on the Albert Memorial in London. When the Sainsbury Wing was being built, the architects were keen that we should put on the staircase a frieze of the names of the half-dozen greatest Renaissance artists. You may imagine their alarm when I suggested that one of those six ought to be The Master of the Saint Bartholomew Altarpiece. Indeed, I do not believe they thought I was being serious. So no German artist is present in our frieze. The north, when it comes to names, is doomed always to lose to the Italians.

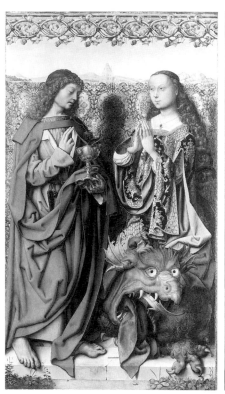
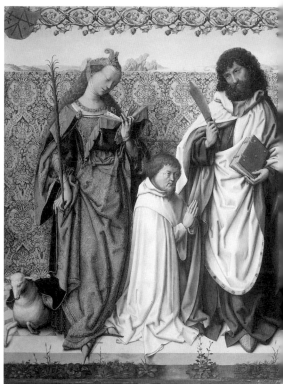

It is self-evident, but perhaps worth stating, that a nameless artist cannot become a household name. He or she cannot become a part of that communal notion of culture so widely shared that it and what it represents can be taken, however hazily, for granted. Many who talk of Titian hair will have only slender notions of Titian's work, but they will know that it is widely admired. A similar homage is paid by travellers in different cities who stay in the Rubens Hotel, or by those who buy the recently produced Rembrandt toothpaste. Undergraduates across the English-speaking world may play Botticelli after supper, but it would be a brave student indeed who suggested that everybody play 'Meister des Münchener Kreuzigungsaltars'.

At a wider level, all of us depend on names, and what we can confidently associate with them, to negotiate daily life. Brand naming

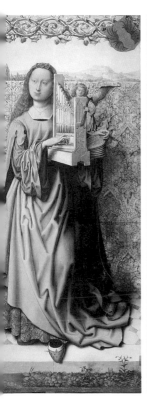

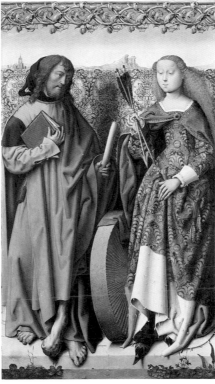

13 *The Saint
Bartholomew altarpiece.*
Alte Pinakothek,
Munich (central panel:
128 × 161 cm; wings:
129 × 74 cm)

was one of the first, and remains one of the fundamental modern
advertising strategies. The huge increase since the 1970s of the
phenomenon of name-franchising shows how deep is our reliance on a
familiar name. Benetton and Burberry, McDonalds and Spudulike,
even the fabricated and unpronounceable Häagen-Dazs, are names that
tell us what to expect. The label beside the picture does the same. I
suspect I am not alone in the slightly guilty knowledge that a label with a
particular name tells me not just who the artist is, but what reaction I
ought to have to the work. A van Gogh label alerts me to an anguish I
ought to be able to discern and share, whatever the subject represented; a
Piero lets me groom myself for refined tranquillity. Unlabelled pictures,
giving no such clues, alarm us.

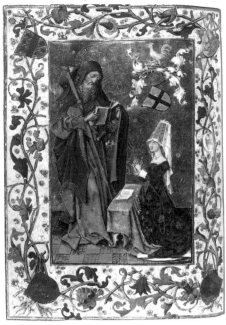

14,15,16 *Above, left and right*: MASTER OF THE SAINT BARTHOLOMEW ALTARPIECE, pages from *The Book of Hours of Sophia von Bylant*, Wallraf-Richartz Museum, Cologne. These are written in the same Netherlandish dialect that appears *below* in the Book of Hours held by Saint Columba, shown here in a detail from the Bartholomew Master's *Saints Andrew and Columba*, Landesmuseum, Mainz

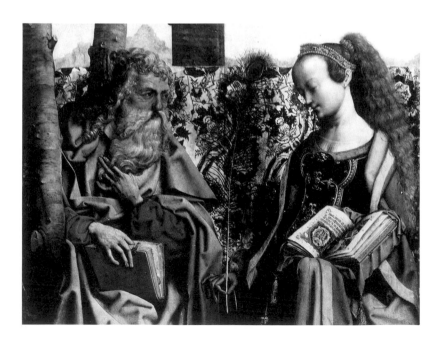

The Master's Identity

With the Bartholomew Master, however, no such difficulties were at first apparent. The Boisserées, who collected him, boldly attributed his work to Lucas van Leyden.[18] It was only some time later that it was realized that Lucas's works possessed different characteristics and that the Bartholomew Master's pictures must, for the most part, have been finished by 1505, which would have made Lucas van Leyden (born, according to Van Mander, in 1494) an extremely infant prodigy. So the Lucas attribution was abandoned. But in the early nineteenth century, if you could not find a name, you might at least find what, for a Romantic thinker, was hardly less important – a national characteristic. In Germany, as in the rest of Europe, the hunt was on for a national past and distinctive national traits. When Friedrich von Schlegel looked at the early Cologne pictures in the Boisserée collection, he insisted: 'Und diese Gemählde sind altdeutsche Gemählde';[19] while Goethe wrote that in looking at a collection of pictures, he hoped to find 'patriotism, to which every state, province, country and even town is entitled'.[20]

It is, however, hard to be confident of finding patriotism and national characteristics if the origin of the artist under investigation is uncertain. And the nationality of the Bartholomew Master is almost as obscure as his name. The earliest work which can be confidently attributed to him, the *Book of Hours of Sophia von Bylant*, contains an illumination dated *14, 15* 1475, and is written not in German, but in an East Netherlandish dialect.[21] Roughly thirty years later, at the other end of his career, in probably one of his last surviving paintings, the *Saints Andrew and Columba*, now in Mainz, the Book of Hours which Saint Columba *16* holds is written in exactly the same dialect.[22] It seems likely therefore that he was familiar with, if not indeed a native speaker of, that particular form of Low German and not, in modern terms, strictly a German artist at all. This hypothesis is lent some weight by the suggestion that the spire we see in the background of the *Portrait of a Man*, now in Cologne, and *1* almost certainly an early work, is the spire of the cathedral in Utrecht.[23]

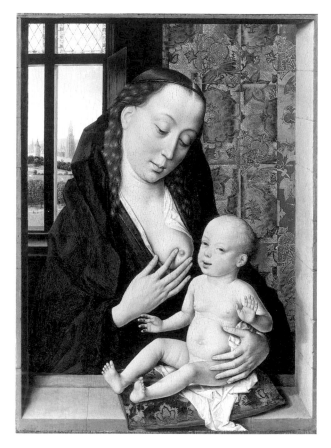

17 DIERIC BOUTS, *Virgin and Child*. National Gallery, London (37 × 27.5 cm)

18 MASTER OF THE SAINT BARTHOLOMEW ALTARPIECE, *Virgin and Child with a Walnut*. Wallraf-Richartz Museum, Cologne (31.2 × 21.7 cm)

Yet whatever his language may have been, and whatever anachronistic nationality we may now want to impose on this inhabitant of a then very supranational Rhine Valley, there can be no doubt that his art is profoundly Netherlandish in its inheritance. If we compare his *Virgin and*
18 *Child with a Walnut*,[24] for example, with a Netherlandish painting of
17 around 1460, the *Virgin and Child* by Dieric Bouts,[25] the similarities are striking. In both we find the strangely angular posture of the Child's arms, legs and feet and a closely comparable treatment of the brocade behind the Virgin. Other comparisons lead to the same conclusion. The

22

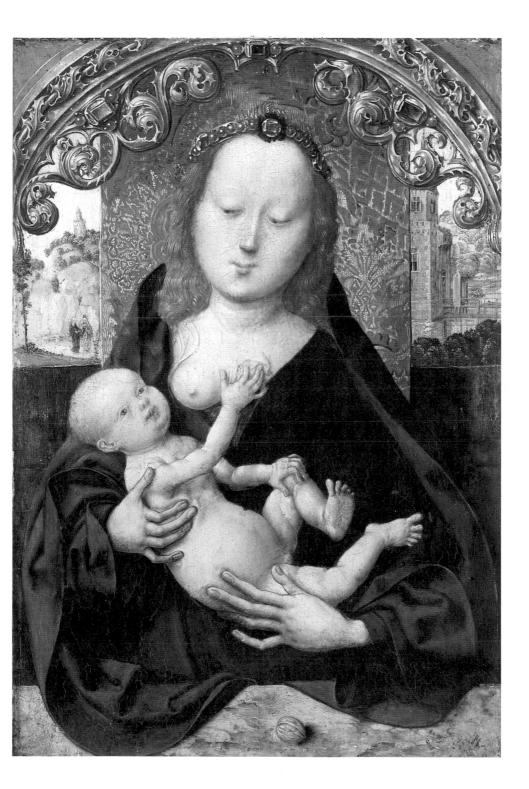

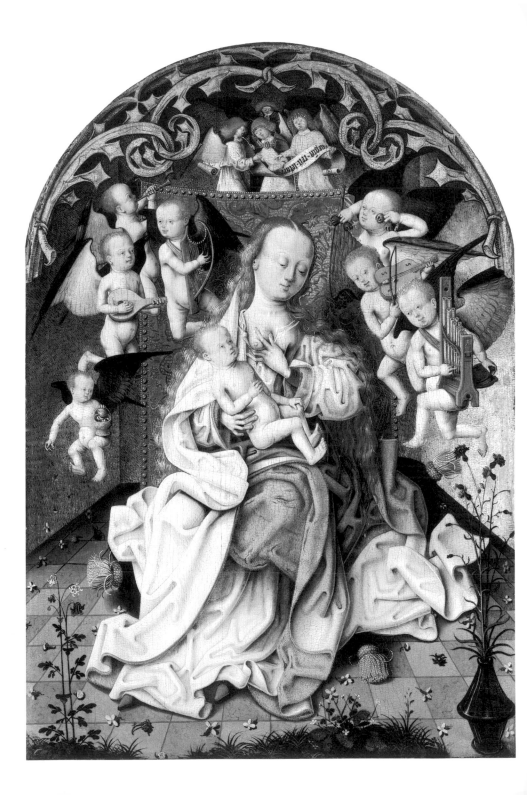

19 MASTER OF THE SAINT BARTHOLOMEW ALTARPIECE, *Virgin and Child with Musical Angels*. National Gallery, London (52 × 38 cm)

20 GEERTGEN TOT SINT JANS, *The Nativity*. National Gallery, London (34 × 25 cm)

facial type of the Bartholomew Master's Virgins, for instance, and indeed 19 of many of the women in his paintings, is clearly close, in its high, almost hemispherical forehead, almond eyes and small pursed-lipped mouth, to the idealized female heads of Geertgen tot Sint Jans, whose *Nativity*, 20 probably of the 1480s, shows a Virgin with just such characteristics.[26]

Rather than the *Meistersinger* world of 'die heil'ge deutsche Kunst', we are dealing then with a painter whose work derives in large measure from the Netherlands – disappointing perhaps to the nineteenth century, but hardly surprising, since Cologne at the time was in artistic terms almost a Netherlandish colony, housing some of the greatest works of Rogier van 21 der Weyden.[27] Our artist may even have been exposed to the much more dangerous taint of 'falscher welscher Majestät', that truly foreign,

Latinate influence which is so roundly condemned in the final scene of Wagner's opera. There is in the Louvre a large *Deposition from the Cross* by the Bartholomew Master,[28] which must, to judge by its frame, have been painted for an Antonite convent. It has been in Paris certainly since the seventeenth century, and may well have been commissioned directly from the artist. This painting raises the possibility that the Bartholomew Master might have visited Paris – a thought which would have alarmed Romantic nationalists – though there is nothing in the rest of his known work to suggest that this was the case.

Whatever his origins, there can be no doubt about his qualities. These speak, however, not of a regional style or a local approach to the world, but of a remarkably distinct personality. He is a painter about whom we very much want to know more, because he is so clearly an artist of the

21 ROGIER VAN DER WEYDEN, *The Deposition*. Prado, Madrid (220 × 262 cm)

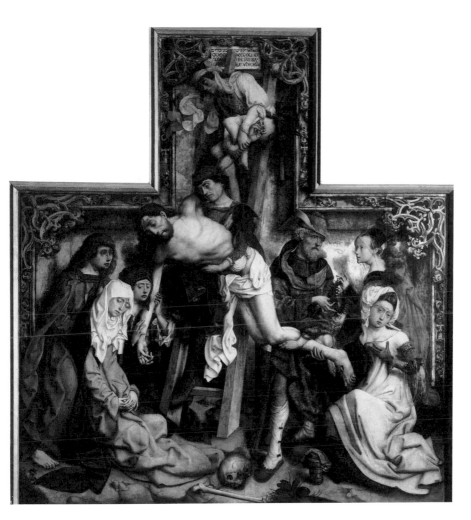

22 MASTER OF THE SAINT BARTHOLOMEW ALTARPIECE, *The Deposition from the Cross*. Louvre, Paris (277.5 at highest point × 210 cm)

utmost idiosyncrasy. Who he is remains unclear. What he is emerges immediately from a comparison of two images: the Mocking of Christ from the *Book of Hours of Sophia von Bylant* of around 1475,[29] and the 23
Deposition in the National Gallery,[30] probably painted about thirty years 24
later. In spite of the distance in time, the similarities are striking. In each

27

23 MASTER OF THE SAINT
BARTHOLOMEW ALTARPIECE,
'The Mocking of Christ', from
*The Book of Hours of Sophia von
Bylant.* Wallraf-Richartz Museum,
Cologne

24 MASTER OF THE SAINT
BARTHOLOMEW ALTARPIECE,
The Deposition from the Cross.
National Gallery, London
(74.9 × 47.3 cm)

there is a fictive wooden frame, carefully constructed at the top of the
picture, then either disregarded or wilfully played against at the bottom,
leaving serious uncertainty about what exactly is being shown, what
precisely the nature of the illusion created. Are we looking at real life, a
painted carving, or a painting of a carving? In each picture there is an
intense interest in physical suffering and the reactions to it, naturally more
highly developed in the later work, but no less central to the earlier one.
And the fascination with bodily deformity that can be seen in the
hideously misshapen figure to the left of the mocked Christ clearly
informs the boy who perches with demonic athleticism on the top of the
cross, as though jeering at the slow clumsiness with which the two older
men struggle down the ladder with the dead body.

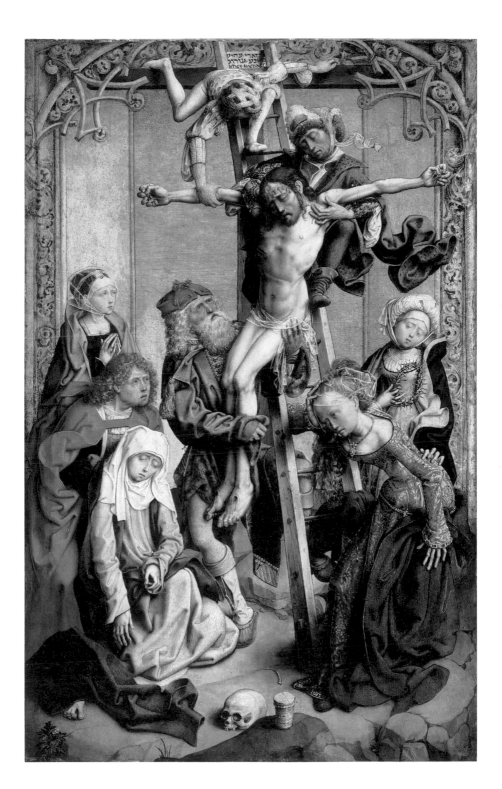

As with van Gogh or Munch, these indices of intense emotions merely whet our appetite for specific information about the man who so powerfully recorded them. And the few provenances which we know or can guess do little more than raise a further set of questions, only to leave these in turn tantalizingly unanswered. The Bartholomew Master painted three large triptychs. Of these, two, the *Incredulity of Saint Thomas*,[31] and the *Crucifixion*,[32] both now in Cologne, were once in the Boisserée collection, and came originally from the Charterhouse on the outskirts of Cologne. From rare surviving documents, we know that both were given by the man whose coat of arms appears on the plinth below Christ and Saint Thomas, Peter Rinck, a successful Cologne lawyer who had once been a Carthusian novice, but, finding the rule too strict, had left the order for the world.[33] The third work, the *Saint Bartholomew altarpiece* itself, shows a Carthusian monk kneeling to the left of the central saint. This figure was, however, subsequently painted over, as were the coats of arms, so it is possible that the kneeling patron died when the painting was on the verge of completion, and we do not know whether it was ever placed in the Charterhouse.

What is certain is that our artist painted three major works with Carthusian connections. It is almost the only certain fact that we do know about him and perhaps for this reason it has led to speculation about the precise nature of his links with the Charterhouse. Indeed, it has even been suggested that the artist was a monk himself. If this were the case, would it in some measure explain his works? And should we expect to be able, just by looking, to tell whether it is likely?

There are some straightforward clues which might take us a little way down the road. The Carthusians, being vegetarians, had a strong interest in botany, and our artist's works are filled with carefully observed flowers – the dianthus at the bottom right of the National Gallery's *Virgin and Child with Musical Angels* is in fact called a Carthusian pink.[34] The strongly mystical spirituality of the Cologne Charterhouse around 1500 might perhaps lie behind the numerous angels, attendant, music-making or grieving, that abound in his work.[35]

Furthermore, the tradition of the Charterhouse is one not of

community, but of individual monks living silently and eremitically together. The *Saint Bartholomew altarpiece*, therefore, with its isolated saints noiselessly looking at each other, might, if we had just a little more information about the artist, be read as a more profoundly Carthusian work than the two earlier altarpieces. There are those, after all, who claim that they can tell by looking at Goya's late works that the artist was deaf. Would we, with a little biographical information, assert that the *Saint Bartholomew altarpiece* clearly comes from the house of a silent order? It would certainly be very tempting to do so.

We are told that for Peter Rinck the austerities of the Charterhouse were too severe and he had to leave. Looking at the flirtatious pairs of male and female saints in the three main altarpieces and, perhaps most of all in the National Gallery's *Saints Peter and Dorothy*, would we, with the *26, 34* benefit of a comparable piece of information, see the struggle of a chaste and celibate artist against the temptations of the flesh, or perhaps even a veiled proto-Lutheran attack on the very notion of monastic celibacy?

What is certain is that if we did have biographical data of this kind, we would persuade ourselves that we could read their traces in the paintings and it would embolden us to write about the works. For it seems at least arguable that it is the ignorance of virtually all personal details about German artists of this period that explains their striking neglect by art historians writing in English. Armed with such factors, and absolved in consequence from the charges of simple projection, we could confidently – or perhaps just tentatively – locate the artist and his works in a cultural, emotional or political world. It is this kind of placing which has particularly preoccupied art historians in recent years, in fact for much of the twentieth century, the *locus classicus* – or do I mean the *reductio ad absurdum*? – being Freud's essay on Leonardo.

Freud felt able to assert that 'Leonardo himself, with his love of truth and his thirst for knowledge, would not have discouraged an attempt to take the trivial peculiarities and riddles in his nature as a starting point for discovering what determined his mental and intellectual develop-ment'.[36] Whatever view we may now take of this celebrated essay, Freud felt he had enough evidence about Leonardo from documents and

biographies – his alleged vegetarianism, his habit of buying caged birds to set them free, and many other revealing attitudes – to enable him to construct an entire personality, a psycho-biography which both elucidated the works and was in turn corroborated by them.

A Life without a Name

Sadly, none of this ingenuity, intellect and imagination can be brought to bear on an artist who has lost his name and has been reconstructed on the basis of his work. There is, after all, always the danger that the personality that engages your interest will literally split in two, as happened to the Master of the Life of the Virgin, who was subsequently declared to be not only himself but also the Meister der Lyversberger Passion, thus resolving one complex personality into a pair of straightforward ones;[37] and it is always more than likely that we are looking at only a part of the artist's work, in any case. A nameless artist, a construct of connoisseurship, whose intellectual and social origins cannot be investigated, who cannot be addressed in terms of politics or gender – he may just conceivably have been a woman – is, for modern art history, dominated as it is by the availability of written sources, little short of a catastrophe.

We have most of us got into a habit of using paintings as documents among other documents, and a very useful and illuminating habit it can be. Few would deny that we can find deeper meanings in Rembrandt's paintings the more we learn about the frequently unappealing complexities of his personal life. Similarly with Seurat: greater knowledge of social patterns in late nineteenth-century Paris allows us to go far beyond a formal response to the scenes at Asnières or the Grande Jatte. But our taste for written evidence has led to some strange distortions of vision. Because of the unparalleled amplitude of the Sèvres archives, the most minor flower-painter at the Sèvres porcelain factory is listed and studied, his biography published and his propensity to bad language recorded, while virtually nothing has appeared in English on the artists of Cologne at the end of the fifteenth century, who are among the greatest painters of their generation in Europe.

It is not clear where we could start looking for the sort of evidence we would like to find, and even the most remorseless interrogators give up when they discover that too many avenues of enquiry are closed. You will remember the exasperation with which Lady Bracknell snapped shut her notebook when she discovered that Jack Worthing had simply lost too many of his connections for her to evaluate him as a prospective son-in-law. There is a real sense in which to be a painter in fifteenth-century Cologne is the art-historical equivalent of being not just found, but born, in a handbag.

If anonymity inhibits discussion of why and how an artist painted while he was alive, consider what its impact is on our study of his reputation and influence after his death. He cannot be traced through inventories or sale catalogues because either he is under the wrong name or no name. He has by the nature of things no biographer, no critical fortuna; no publisher would lightly embark on his monograph. Is it a coincidence that the painter of that supreme early French altarpiece in the Louvre, the Villeneuve-lès-Avignon *Pietà*, was the subject of a book only after he had, however questionably, been given the name Enguerrand Quarton?[38] Most nameless artists are indeed, in the words of *Ecclesiasticus*, 'become as though they had never been'.

This matters at a level far deeper than the art-historical. Myth and religion, fairy-tales and children's stories all speak of the importance of being able to name, and of the relationship between the namer and the named. It is an anthropological commonplace that Adam took control of the animals by the very act of naming them, just as Christ was able to cast out devils by the same stratagem, and it is only when the Princess eventually discovers Rumpelstiltskin's name that she is free of his power. Siegmund is far more threatening as long as he is Namenlose, and the most sinister line in the whole of *Macbeth* is the one which tells of the witch engaged in 'a deed without a name'.

But more appropriate for our artist, who shows a rare sense of humour, is Kipling's account in the *Just So Stories* of the young jaguar who has come across a puzzling and frightening object, an animal which is not quite a hedgehog yet not quite a tortoise either.[39] 'It's a little bit of both,'

he complains to his mother, 'and I don't know its proper name.' 'Nonsense,' says Mother Jaguar, 'Everything has its proper name. I should call it "Armadillo" till I found out the real one. And I should leave it alone.' Although German colleagues tell me that their visitors are not deterred by anonymity, it is fairly clear that most Anglo-Saxons have followed Mother Jaguar's advice, have reluctantly accepted a Notname as inevitable, and have left unknown artists alone.

The Artist and His Work

The nameless artist who concerns us here, clearly a master, seems to have had a considerable workshop, with a group of apprentices and journeymen who could produce works in his style. The study of the underdrawing in his paintings through infra-red reflectography, though still in its early stages, points clearly to such a workshop structure. In the National Gallery, for example, is a small portable triptych, which has many echoes of the Master's style.[40] Most likely a studio product, it may, however, rather be evidence of the Master's influence beyond his workshop, a homage of imitation from a lesser artist.

Yet however wide his impact on contemporaries may have been, however extensive his own studio production, the Master's personal style is clearly distinguishable, as, broadly, are the lines of development within it. There would be little dispute about the common authorship of the John the Baptist in the *Book of Hours of Sophia von Bylant* and the John the Baptist of roughly twenty-five years later who stands beside Saint Cecilia in the *Crucifixion altarpiece* in Cologne. The *Book of Hours* can be fairly safely dated to around 1475, and must be among the earliest of his surviving works. The Cologne saint's more complicated yet more assured posture, the greater subtlety in the colours of his layers of clothing and the slightly comic nervousness with which his lamb looks down at the dead lion's head all speak persuasively for a considerably later date. We know it was given to the Cologne Charterhouse by Peter Rinck, who died in 1501, and from the documents it appears to have been commissioned shortly before his death.

From quite an early stage the Bartholomew Master seems to have

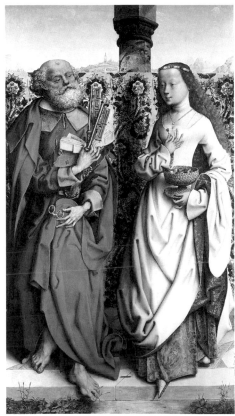

25 MASTER OF THE SAINT BARTHOLOMEW ALTARPIECE, *Saints Andrew and Columba* (detail). Landesmuseum, Mainz
26 *Saints Peter and Dorothy* (detail). National Gallery, London

been intrigued by the confrontation of the human and the divine, which is surely the central preoccupation of the *Baptism*, now in Washington, 27 where the earthly scene is witnessed by the fourteen holy helpers, a group of saints particularly venerated in the Rhineland, who protected against plague, disease and other catastrophes. He has clearly had trouble in organizing the large number of saints into a satisfactory composition (not

35

something he was to try again) and the recession of the landscape has proved problematic. Even more teasing has been the transition from a landscape that is effectively real to one that is demonstrably imaginary. It must have been clear to him that if he were going to tackle this sort of subject again, he would have to devise different approaches.

28 One such is what we see in the *Incredulity of Saint Thomas altarpiece*, possibly dating from the late 1480s, and also given to the Cologne Charterhouse by Peter Rinck. The meeting of the divine Christ and the human Thomas is again witnessed by airborne saints, but this time spatial recession is happily lost in obscuring clouds. Everything is focused on the shocking, crude vigour with which Christ takes Thomas's hand and thrusts it firmly into the wound in his side. Two worlds have collided and we can see how distressing that collision is from the reactions of the two music-making angels. The right-hand angel hurdy-gurdies happily on, like so many of the Bartholomew Master's other angels. But the left-hand angel has seen what has taken place, has

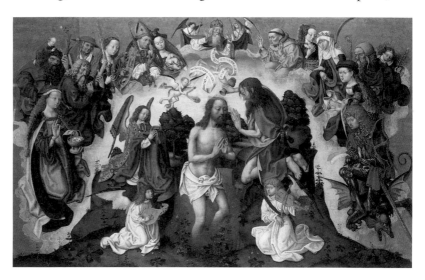

27 MASTER OF THE SAINT BARTHOLOMEW ALTARPIECE, *The Baptism of Christ.* Samuel H. Kress Collection, National Gallery of Art, Washington, D.C. (106 × 170 cm)

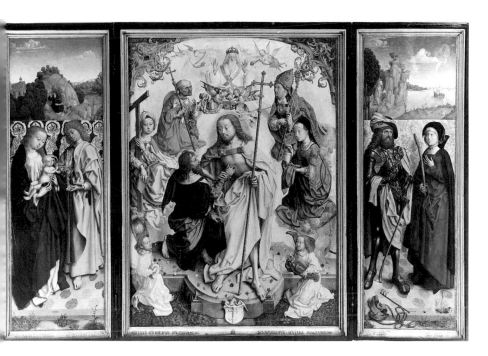

28 MASTER OF THE SAINT BARTHOLOMEW ALTARPIECE, *The Incredulity of Saint Thomas altarpiece*. Wallraf-Richartz Museum, Cologne (central panel: 143 × 106 cm; wings: 143 × 47 cm)

seen that Thomas may be inflicting pain on Christ, has seen the violence and the horror of what is going on. He is no longer smiling, no longer playing: his hand is suspended above the string. The suffering of Christ is so deep that it disrupts the harmony of the angels.

The triptych format, however, allows the artist to use the wings to try out other approaches to problems both artistic and religious. With none of the *trompe-l'oeil* fretwork of the central panel, the four saints are shown, standing securely on a pavement, the middle distance that had proved so troublesome in the *Baptism* blotted out by a beautifully executed piece of hanging brocade.

On the right, the two martyr saints, Hippolytus and Afra, are shown in carefully contrasted poses, turned to each other not so much as though about to speak, as about to embark on a courtly dance. There is none of

37

the brutality of the central panel's view of suffering here. Hippolytus is shown in the armour he wore as a soldier before his conversion, and the small harness at his feet is the discreetest reminder of his excruciating death, torn limb from limb by four horses. Saint Afra, holding the distaff under which she concealed a bishop, is dressed like the fashionable prostitute she was before her conversion. But the fire on which she ultimately perished in Augsburg is reduced to a tiny, ostentatiously unthreatening, bunch of kindling twigs. While Christ's suffering is perpetual, that of the saints – or at least these saints – is over. They are well-dressed, civilized, elegant people, who, having long ago suffered once, now have time to think of other things.

This sharply differentiated approach to the enduring Passion of Christ and the perpetual bliss of the saints, artistically rare though theologically sound, allows the artist to investigate a quite extraordinary 29 range of emotions within one work; and in the *Crucifixion altarpiece*, probably painted a few years later, he took the formula a stage further. In the middle we have once again the suffering of Christ, epitomized this time by the virtuoso *trompe-l'oeil* of the nail in his foot, at what may well have been the viewer's eye-level. Behind him lies Death, for the moment victorious, while around him angels and saints give themselves over to private grief. A fictive fretwork frame leaves us uncertain as to whether we are looking at a representation of living figures, or of painted sculpture.

In the wings the fretwork, with the sky showing through, is clearly revealed as no more than a *jeu d'esprit*, and the whole mood must be read as one of cultivated humour rather than of pathos. The relations between the wings and between the two sets of male and female saints have been carefully, mischievously calculated. Upper left and bottom right, Saint John the Baptist's and Saint Agnes's lambs echo one another, each ludicrously diminutive and demure. On the right wing, Saint Alexis, the rich man turned beggar, looks longingly at Saint Agnes, who holds up an admonitory palm-frond and affects complete absorption in her Book of Hours. The left wing, by contrast, shows the situation between the sexes reversed, with Saint Cecilia distracted from her music by John

38

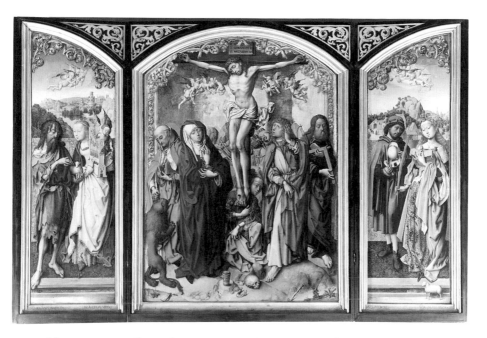

29 MASTER OF THE SAINT BARTHOLOMEW ALTARPIECE, *The Crucifixion
altarpiece*. Wallraf-Richartz Museum, Cologne (central panel: 107 × 80 cm; wings:
107 × 34 cm)

the Baptist's wild, unkempt looks, while he seems quite taken up with
the task of stroking his tiny lamb.

Above the brocade on each wing we glimpse a wide landscape, a
fantasy Rhineland that recedes into a brilliant aerial perspective blue.
The artist must here be consciously playing not just with different
emotional registers, but with different conventions of representation in
the same art-work: fictive polychrome sculpture in the central panel with
a *trompe-l'oeil* nail plumb in the middle; 'real' figures presented in front of
a bolt of brocade and a landscape on the inner wings; and, on the outside
wings, grisaille, visible only when the altarpiece was closed, a third kind
of illusion – fictive monochrome sculptures showing Peter and Paul and
the figures of the Annunciation.

In a sense, of course, it could be argued that this blurring of the
boundaries of sculpture and painting is a commonplace in German art.

The supreme surviving example of the phenomenon must be Michael Pacher's *Saint Wolfgang altarpiece*, in which the central panel is actually carved polychrome sculpture, while the wings are painted panels.[41] There can be little doubt that this is the tradition in which the Bartholomew Master was working, and there can be virtual certainty that he knew what is probably its most sophisticated example, Rogier van der Weyden's *Deposition*, now in the Prado.[42]

21

It is virtually certain that Rogier's work lies behind our artist's *Deposition* in the Louvre, where, for the only time in the paintings now known to us, he uses figures that are fully life size. Yet if it is obvious how much he was indebted to van der Weyden, it is also clear how far he differentiated himself from him. Where Rogier creates a powerful tension by effectively respecting the convention of the carved figures in the box, the Bartholomew Master quite deliberately breaks it, with the head of Christ cutting across the corner and the three figures at top and sides all projecting forwards. While the implication may be that Christ's suffering, like the fictive space, is unconfined, there remains an uncomfortable suspicion that the artist has fallen between two representational stools.

22

The Paris picture must, I believe, be earlier than the National Gallery *Deposition*, which seems to be an intensely private resolution and distillation of the life-size work. Just as in the Cologne altarpieces, the upper part of the painting suggests that this is a polychrome sculpted altarpiece, while the lower part spills out in front of the fictive arch, where all the action takes place. A series of extraordinary contrasts is set up, between the miraculously supple boy and the uncannily straight arms of Christ, rigid in death; between the elegant, almost fancy, dress of both Nicodemus and Joseph of Arimathea and their gauche attempts to manhandle the dead and naked body; between their cumbersome wealth and Christ's destitution; between the staggering Magdalen and the slumped and swooning Virgin. Working within a strict convention of great refinement, the artist nonetheless carefully distinguishes the range of emotional responses among those at the foot of the cross. Facial expression, pallor and tears are complemented by the two sharply

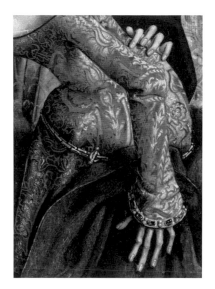

30,31 MASTER OF THE SAINT BARTHOLOMEW ALTARPIECE, *The Deposition from the Cross* (details). National Gallery, London

differentiated hands on the right of the painting – the comforting touch of *30* the figure holding the crown of thorns and, just below, the Magdalen's fingers splayed in distraction. On the other side, all the grief of John the Evangelist can be read in the clenched toe that protrudes from beneath *31* the blue of the Virgin's robe. We are in the presence here of one of the most profoundly meditated and intensely felt Depositions ever painted.

Late Works

The last two works under consideration are quite different in tone. They are the *Saint Bartholomew altarpiece* itself, probably painted in the early *13* 1500s, and what I believe to be his last work, the National Gallery *Saints* *26* *Peter and Dorothy*,[43] with the pendant *Saints Andrew and Columba*, now in *16* Mainz.

In the *Saint Bartholomew altarpiece*, the artist has extended across all three panels the formula he devised for the wings in Cologne – and appropriately so, since the central panel here has no narrative scene of suffering, but three further saints and the donor. In the paired male and

female saints in the wings, there is the same careful symmetry of pose that we have seen before, but the humour of the animals is carried to a new level. Saint John the Evangelist at the far left holds in his chalice a tiny dragon – symbolizing poison – which he quells with his blessing. But at his feet, on a completely different scale, is the enormous dragon from whose back Saint Margaret is emerging miraculously unscathed. This dragon, shown still in the process of swallowing the end of Saint Margaret's robe, claws the step furiously, evidently bent on devouring something else as soon as possible. Only a few inches away, and clearly in the front line, is Saint Agnes's lamb. But it is completely unconcerned. It seems to know that there is no cause for alarm: the dragon is on a different panel, and that – in the world of painting – is just as safe as having him behind bars.

In the pupil of the dragon's eye is a reflection impossible to reproduce, but easily visible in the painting itself. It shows a small human face – perhaps the artist's? – and reminds us that this is not just a work of art but of artifice.[44] It is the mood which informs both of the last pairs of standing saints.

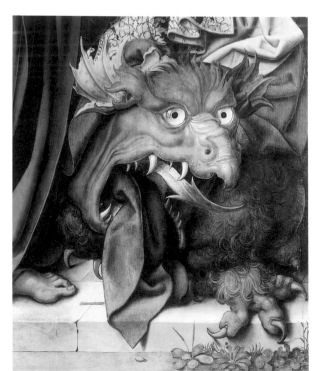

32 *The Saint Bartholomew altarpiece* (detail). Alte Pinakothek, Munich

33 Illustration from Otto Brunfels's herbal, *Kreuterbuch Contrafeyt*, 1546

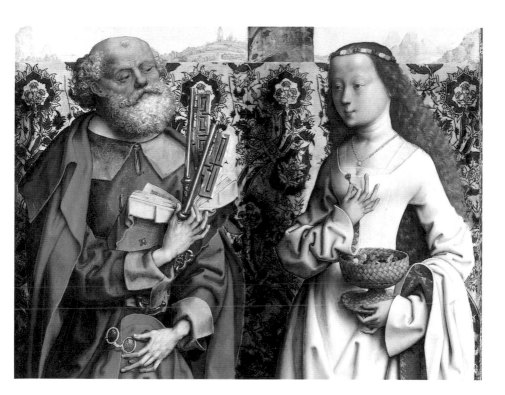

34 MASTER OF THE SAINT BARTHOLOMEW ALTARPIECE, *Saints Peter and Dorothy* (detail). National Gallery, London

In spite of his enormous cross, Saint Andrew eagerly tries to engage Saint Columba in conversation, just as Saint Peter, cluttered with his *34* huge keys and awkward book, appears to have taken off his spectacles in order to have a proper look at Saint Dorothy. Both men are old, and the years show as much in their bunioned feet as in their grey beards and clumsy gestures. Neither of the young female saints pays much attention – one has the distinct impression that this is not the first time a male saint has sidled along the pavement towards them. Saint Columba holds a Book of Hours in such a way that we, at least, can see the illustration: Adam and Eve in the mouth of hell. Is the warning directed at us or at Saint Andrew? Saint Dorothy contents herself by coyly playing with a pink. We do not know whether these panels originally flanked a central

scene. Taken on their own, however, they are an ironic variation on the common European theme of youth and age, the incompatibility, even in heaven, of May and December.

From top to bottom, they are a virtuoso performance in painting. The plants in the foreground have the botanical precision of printed illustrations of the period: a herbal of a few decades later by the Carthusian Otto Brunfels makes the point.[45] The control of light on Saint Dorothy's brocade and the modelling of the pearls round her neck speak a quite different kind of observation and a remarkable skill in the manipulation of oil paint. And at the top, in complete contrast to the naturalism of the plants, is a thin strip of blue landscape – pure fantasy.

Our artist is here playing, as he has before, but this time at the highest level, a game about representation and about looking. Appropriately enough, the game reaches its conclusion in Saint Peter's spectacles. Taken off to let him see Dorothy, they let us see the reflection of a window, bringing us literally down to earth, reminding us that this is a confection, and that Peter and Dorothy are in fact standing not in heaven, but in a room in Cologne. These two panels, possibly the last paintings that the Master of the Saint Bartholomew Altarpiece made, seem to me to be works of great humanity and humour, the culmination of the artist's extraordinarily personal treatment of the German convention of paired saints, and meditations on the very nature of illusion and art.

We are in the presence here of a painter who has been unjustly neglected, an artist of unusual range, capable of sublime piety and the most moving investigation of feeling, but capable also of the boldest mixing of high and low forms of art, combining tenderness and refinement with burlesque. And throughout his work there is a conscious, a self-conscious, delight in the collision of different conventions. The world he creates has more than a little in common with Richard Strauss's *Ariadne auf Naxos*, where, in a world of strictly comparable refinement, high and low art are similarly juxtaposed, and each is given an added charge by contact with the other.

But in inviting us to see through artifice, as he does in *Saints Peter and*

44

Dorothy, the Bartholomew Master perhaps comes closest to the Mechanicals' production of 'Pyramus and Thisbe' in *A Midsummer Night's Dream*. Worried that the audience might be deceived by the illusion and therefore frightened, the fearsome lion, as terrifying as the Bartholomew Master's dragon, steps forward:

> Lion:
>> *You, ladies, you, whose gentle hearts do fear*
>>> *The smallest monstrous mouse that creeps on floor,*
>> *May now, perchance, both quake and tremble here,*
>>> *When lion rough in wildest rage doth roar.*
>> *Then know that I, one Snug the joiner, am*
>> *A lion fell . . .*

In *Saints Peter and Dorothy*, we find just the same insistence that this is only makebelieve: Saint Peter is also Snug the joiner, and that is funny. But it is also moving, because it is true; in real life, in the Gospels, as in the picture, Saint Peter was indeed Snug the joiner, or rather Snug the fisherman, not a remote heroic figure, but an ordinary old man with sore feet and failing eyesight. We find in our artist, in short, that ability to combine rules and conventions with the deepest personal feelings and insights that, according to *Meistersinger*, deserves to win the contest, or at the very least deserves to be better known.

Which brings me, finally, back to the question of names. I have argued that naming gives us power over things. But the corollary of this is that nameless things keep their power over us. Because we know nothing about this artist, the dialogue with his works is conducted on their terms rather than on ours. Those terms are very particular: a refusal to distinguish between high and low art, a deliberate mixing of the genres that both reveals his art and deepens our emotion, a constant collision between the physical and the spiritual, controlled and defused by irony. If paintings have no documentation, it is very much harder for us to tackle them historically. We are forced to consider them primarily in terms of how they speak to us now. For a work of art, that is perhaps not a bad thing.

ACKNOWLEDGMENTS

In preparing this lecture I have incurred many debts of gratitude to colleagues at home and abroad. I should like particularly to thank my predecessor, Sir Michael Levey; Alistair Smith, whose 1977 exhibition of Cologne paintings opened many eyes; Dr Frank Günter Zehnder of the Wallraf-Richartz Museum, Cologne; Dr Gisela Goldberg of the Alte Pinakothek, Munich; Dr John Hand of the National Gallery of Art, Washington, D.C.; Susan Foister, Grizelda Grimond, Erika Langmuir, Anne Luckhurst and Patricia Williams of the National Gallery, London; Richard Beresford, Lorne Campbell, Bamber Gascoigne, John House and Catherine Reynolds.

NOTES

1 Master of the Saint Bartholomew Altarpiece, National Gallery (N.G.) Nos. 707, 6470 and 6499.

2 See J. Dunkerton, S. Foister, D. Gordon and N. Penny: *Giotto to Dürer, Early Renaissance Painting in the National Gallery*, London, 1991.

3 The fullest discussion of the National Gallery's German paintings is in Michael Levey: *National Gallery Catalogues, The German School*, London, 1959. Pictures acquired after that date are discussed in the relevant National Gallery Reports.

4 See Dunkerton and others, *op. cit.* at note 2 above, pp. 54–57.

5 The document discussed by Rainer Brandl: 'The Liesborn Altar-piece, a new reconstruction', *The Burlington Magazine*, March 1993, pp. 180–89, demonstrates how different the German situation is from the Italian: it dates from many years after the painting itself was completed, it is not at all certain that it relates to this picture and it may not even relate to the relevant church.

6 N.G.722; see Levey, *op. cit.* at note 3 above, pp. 106–07.

7 See Susan Foister: 'The Portrait of Alexander Mornauer', *The Burlington Magazine*, Sept., 1991, pp. 613–18.

8 The clearest example of the didactic basis of ninteenth-century purchases at the National Gallery is the acquisition of the Lombardi-Balbi collection; see M. Davies: *National Gallery Catalogues, The Earlier Italian Schools*, London, 1961, pp. 565–67.

9 The woodcut appears in Werner Rolevinck: *Fasciculus Temporum*, Cologne, 1474. Illustrated in *Die Kölner Kartause um 1500: Aufsatzband*, Kölnisches Stadtmuseum, 1991, p. 240.

10 N.G.866. A closely related work, also showing the cathedral from this angle, is in the Wallace Collection, London, P195.

11 See Frank Günter Zehnder's introduction to the exhibition catalogue, *Late Gothic Art from Cologne*, National Gallery, London, 1977.

12 *Goethe on Art*, ed. John Gage, London, 1980, p. 139.

13 Johann Jacob Merlos: *Kölnische Künstler in Alter und Neuer Zeit*, ed. E. Firmenich-Richartz, Düsseldorf, 1895.

14 See Rainer Budde: *Köln und seine Maler, 1300–1500*, Cologne, 1986, p. 64.

15 For the Boisserées' account of their collecting, see Gisela Goldberg and Gisela Scheffler: *Altdeutsche Gemälde, Köln und Nordwestdeutschland; Bayerische Staatsgemäldesammlungen, Alte Pinakothek*, Munich, 1972, pp. 12–13.

16 See Levey, *op. cit.* at note 3 above, p. 84.

17 *Ibid.*, p. 91.

18 See Goldberg and Scheffler, *op. cit.* at note 15 above, p. 17, inventory no. 29.

19 Quoted in Herbert Reiners: *Die Kölner Malerschule*, Mönchen Gladbach, 1925, p. 1.

20 *Goethe on Art, op. cit.* at note 12 above, p. 146.

21 *The Book of Hours*, now in the Wallraf-Richartz Museum, Cologne, is fully described in Paul Pieper: 'Das Stundenbuch des Bartholomäus-Meisters', *Wallraf-Richartz Jahrbuch*, XXI, 1959, pp. 97–158.

22 *Ibid.*, pp. 141–42.

23 Frank Günter Zehnder: *Kataloge des Wallraf-Richartz-Museums, Katalog der Altkölner Malerei*, Cologne, 1990, No. 882, pp. 419, 420.

24 *Ibid.*, No. 578, pp. 442–47.

25 Illustrated and discussed in Dunkerton and others, *op. cit.* at note 2 above, pp. 288–89.

26 *Ibid.*, pp. 340–41.

27 For the strong links between the Master of the Saint Bartholomew Altarpiece and Netherlandish art, see especially Frans Baudouin: 'Der Meister des Bartholomäusaltares und die südniederländische Malerei des

15. Jahrhunderts', in *Wallraf-Richartz Jahrbuch*, XXIII, 1961, pp. 353–58.

28 Louvre, Inv. 1445, 227.5 by 210 cm. See Nicole Reynaud: *Les Primitifs de l'Ecole de Cologne. Les dossiers du département des peintures*, 9, Paris, 1974, no. 13.

29 Illustrated in colour in Pieper, *op. cit.* at note 21 above, p. 120.

30 Illustrated in colour and discussed in Dunkerton and others, *op. cit.* at note 2 above, pp. 368–69.

31 Wallraf-Richartz Museum 179, discussed fully by Zehnder, *op. cit.* at note 23 above, pp. 422–33.

32 Wallraf-Richartz Museum 180, *ibid.*, pp. 433–41.

33 For a biography of Peter Rinck, see Wolfgang Schmid: 'Bürgerschaft, Kirche und Kunst: Stiftungen an der Kölner Kartause (1450–1550)', pp. 391–94, in *Die Kölner Kartause um 1500*, exhibition catalogue (*Aufsatzband*), Kölnisches Stadtmuseum, Cologne, 1991.

34 *Dianthus carthusianorum*, the Carthusian pink, or Karthäusernelke, is discussed in *Die Kölner Kartause um 1500, Eine Reise in unsere Vergangenheit, Katalog*, Kölnisches Stadtmuseum, Cologne, 1991.

35 For a discussion of the Carthusian combination of communal and cenobitic spirituality, see Hermann Joseph Roth: 'Kartäuserspiritualität: am Beispiel der Kölner Kartause um 1500', in *Die Kölner Kartause um 1500, Aufsatzband, op. cit.* at note 33 above.

36 Sigmund Freud: *Leonardo da Vinci*, trans. Alan Tyson, London, 1963, p. 178.

37 See Goldberg and Scheffler, *op. cit.* at note 15 above, pp. 280 and 307.

38 Charles Sterling: *Enguerrand Quarton,*

le Peintre de la Pietà d'Avignon, Paris, 1983.

39 Rudyard Kipling: *Just So Stories*, London, 1952, p. 110.

40 N.G. 6497. See *The National Gallery Report*, 1985–87, pp. 14–15.

41 Pacher's great Wandelaltar is still in the church for which it was painted, Sankt Wolfgang on the Wolfgangsee, Austria. See Eberhard Hempel: *Das Werk Michael Pachers*, Vienna, 1938, ills 20–73.

42 Prado, No. 2825, 220 by 262 cm.

43 The dating of this pair of panels is uncertain, although they are generally agreed to be late. In the management of the interrelationship between the saints, and the three differentiated zones of the painting — pavement, brocade and landscape — they seem to me more accomplished and more confident than the *Saint Bartholomew altarpiece* itself, and I therefore date them later.

44 Goldberg and Scheffler, *op. cit.* at note 15 above, p. 237.

45 Otto Brunfels: *Kreuterbuch Contrafeyt*, Frankfurt am Main, 1546, XIX.

PHOTO CREDITS

Bayerische Staatsgemäldesammlungen (Munich) 13, 32; Bildarchiv Foto Marburg 16, 25; Mas (Barcelona) 21; Reproduced by courtesy of the Trustees, The National Gallery, London 2, 3, 4, 5, 6, 7, 8, 10, 12, 17, 19, 20, 24, 26, 30, 31, 34; Samuel H. Kress Collection © 1993 National Gallery of Art, Washington, D.C. 27; Réunion des Musées Nationaux (Paris) 22; Rheinisches Bildarchiv (Cologne) 1, 11, 14, 15, 18, 23, 28, 29